Coloring Colorado
Beautiful Mountain Vistas

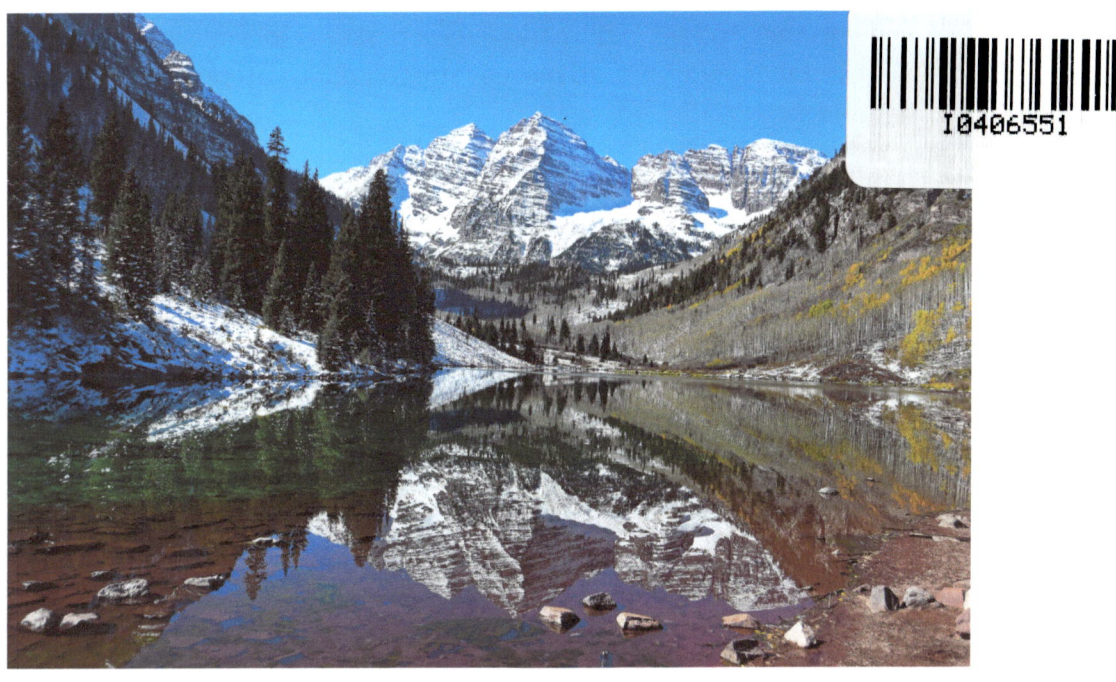

A Grayscale Coloring Book

Beth Ingrias
Bethingrias@gmail.com
Copyright All Rights Reserved

ISBN-13: 978-1533051004
ISBN-10: 1533051003

Want to color more for FREE?

Get a FREE 25 page adult coloring book
visit
www.BethIngrias.com

Coloring grayscale images is an easy way to create a work of art without hitting that creative roadblock that often appears when it is time to start adding depth with shading. All of the shading is already in place on the image. All you need to do is add your favorite colors.

You could think of this type of coloring as shading with training wheels. Not only is it very easy to get excellent results, but you can also learn quite a bit about how light, shadows and shading help to add depth to an image. Don't fight the gray areas. Use them to your advantage to give your work of art depth.

I highly recommend coloring these pages with markers. Use darker colors in the darker areas and light colors in the lighter areas. If you find that your finished piece is still too dark, you can go back over the lighter areas with colored pencils.

To make the entire process easier for you, I have included the original full color image of each beautiful mountain vista for inspiration! This gives you the opportunity to see which colors nature chose the instant I took the photograph.

You won't find these images anywhere else. Each one comes from its own unique location somewhere in the incredible picturesque mountains of Colorado.

Have fun and enjoy!
Beth

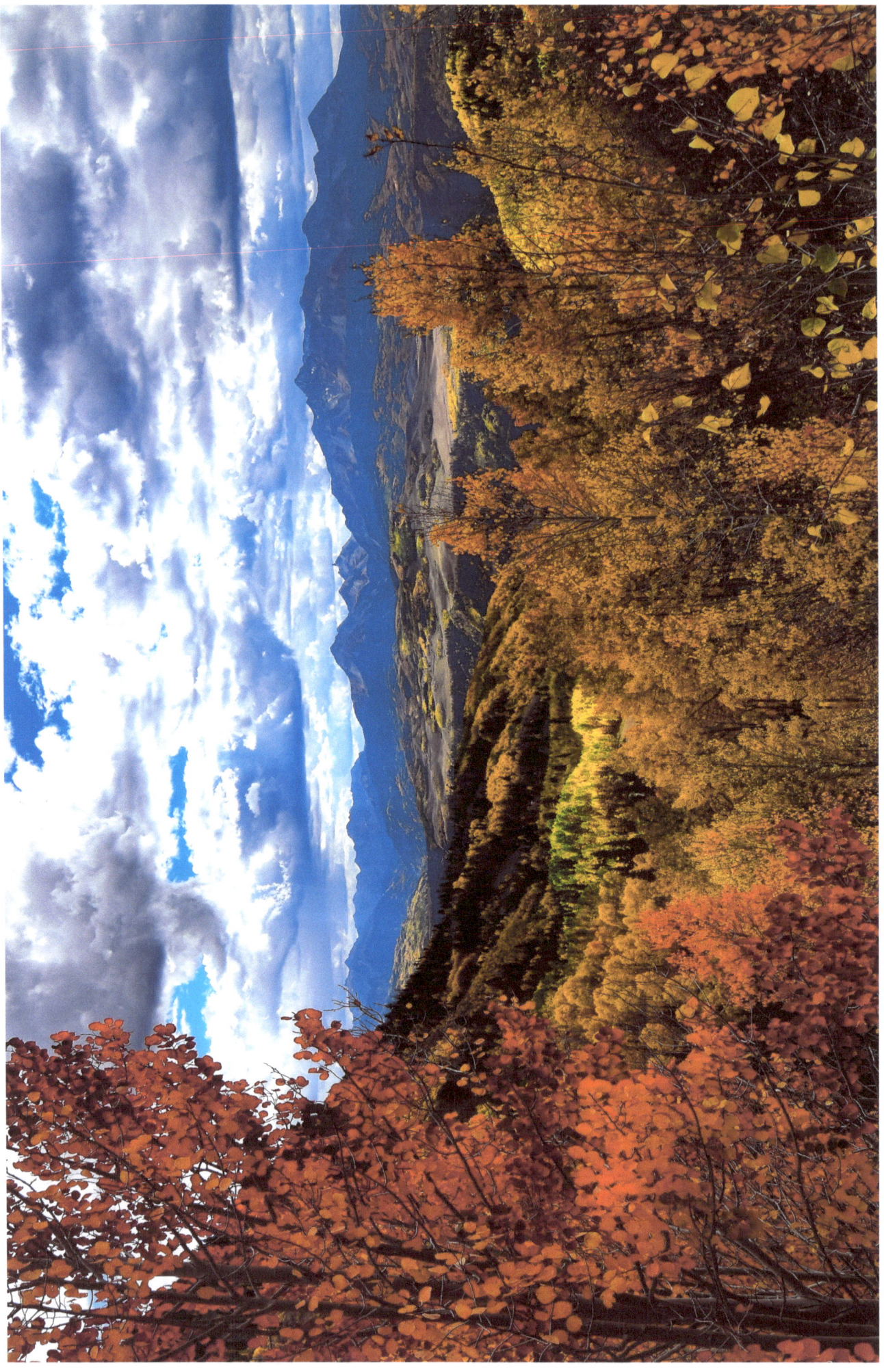

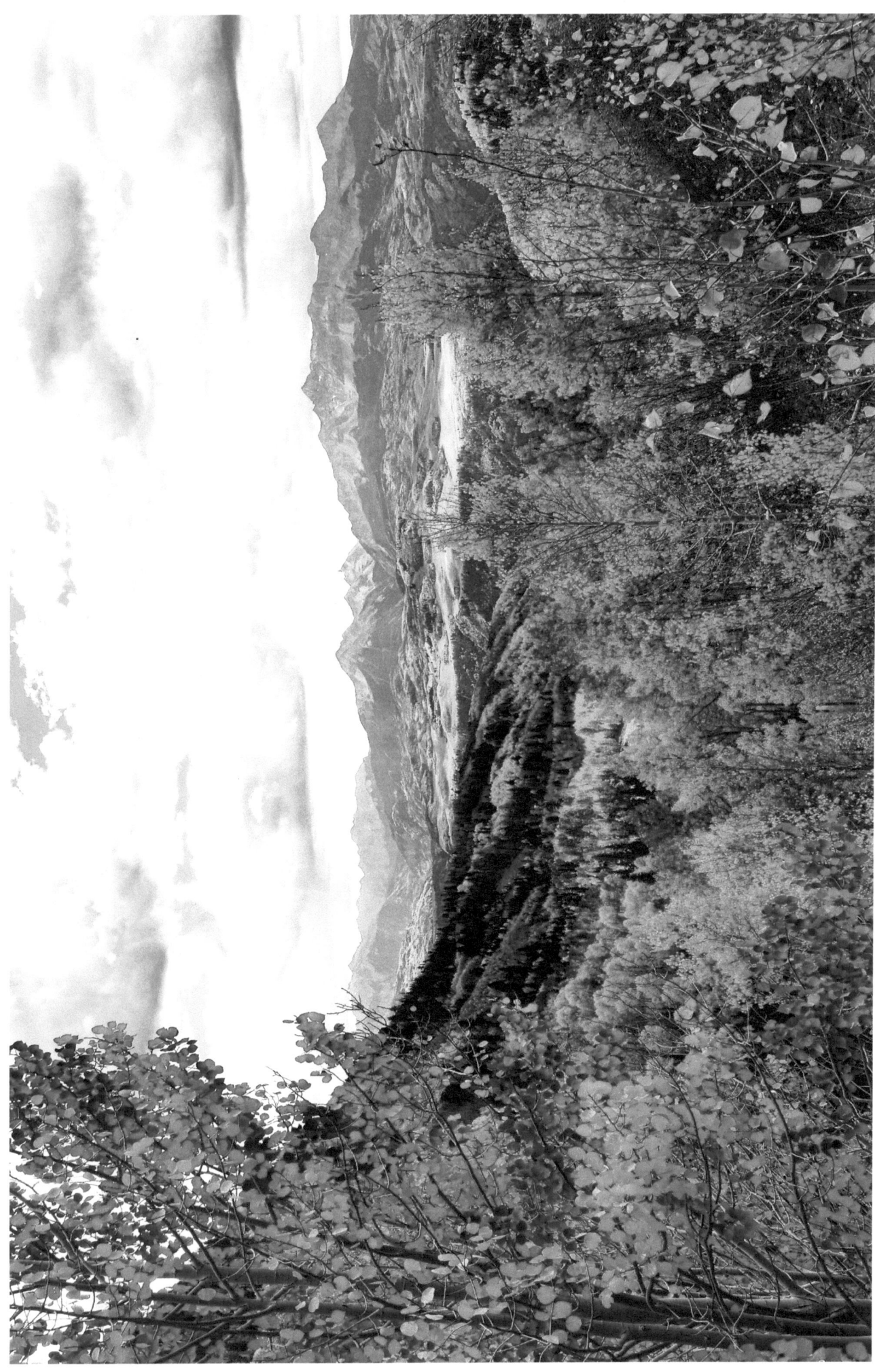

Page is intentionally blank to prevent bleed-through.

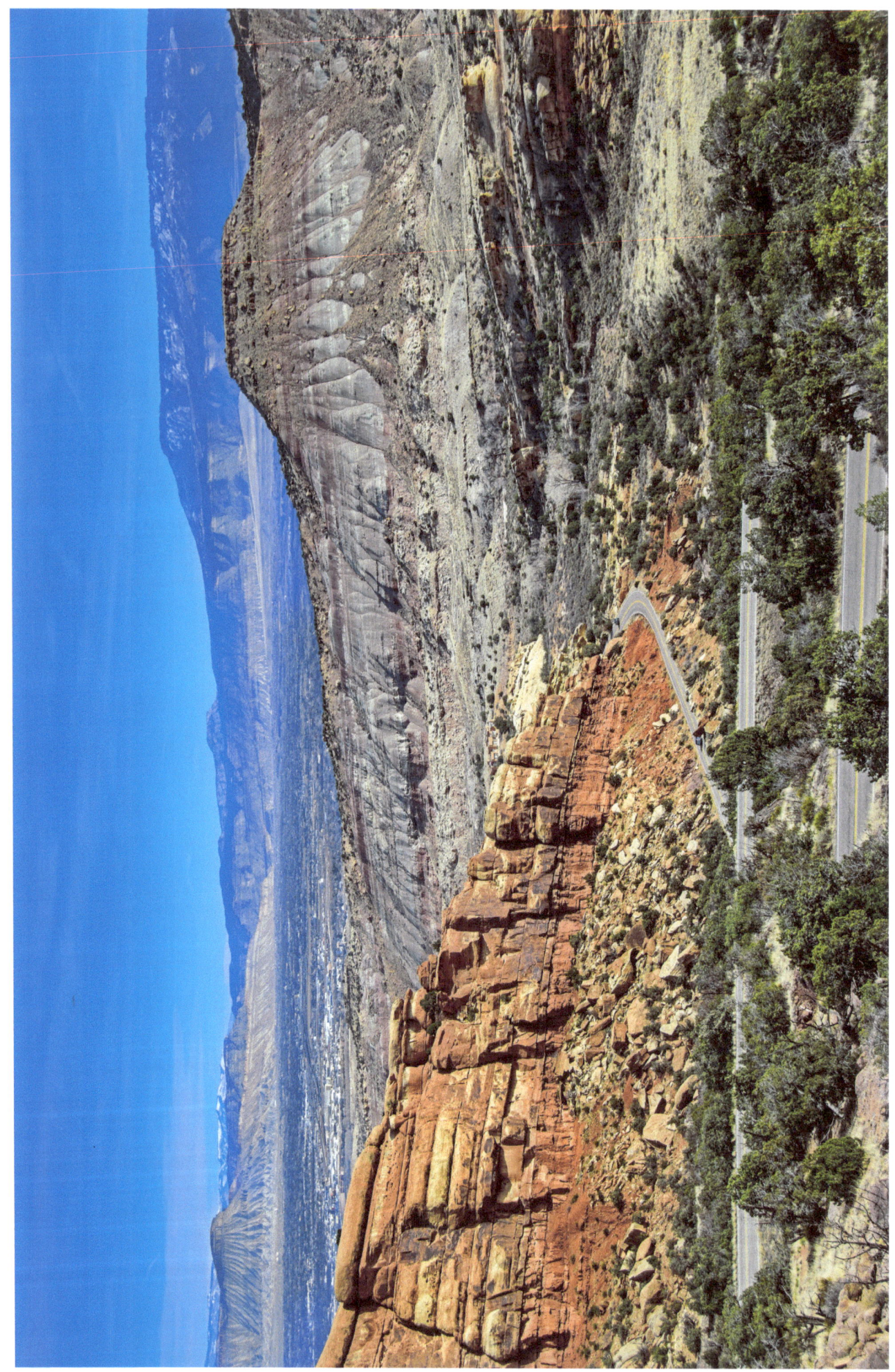

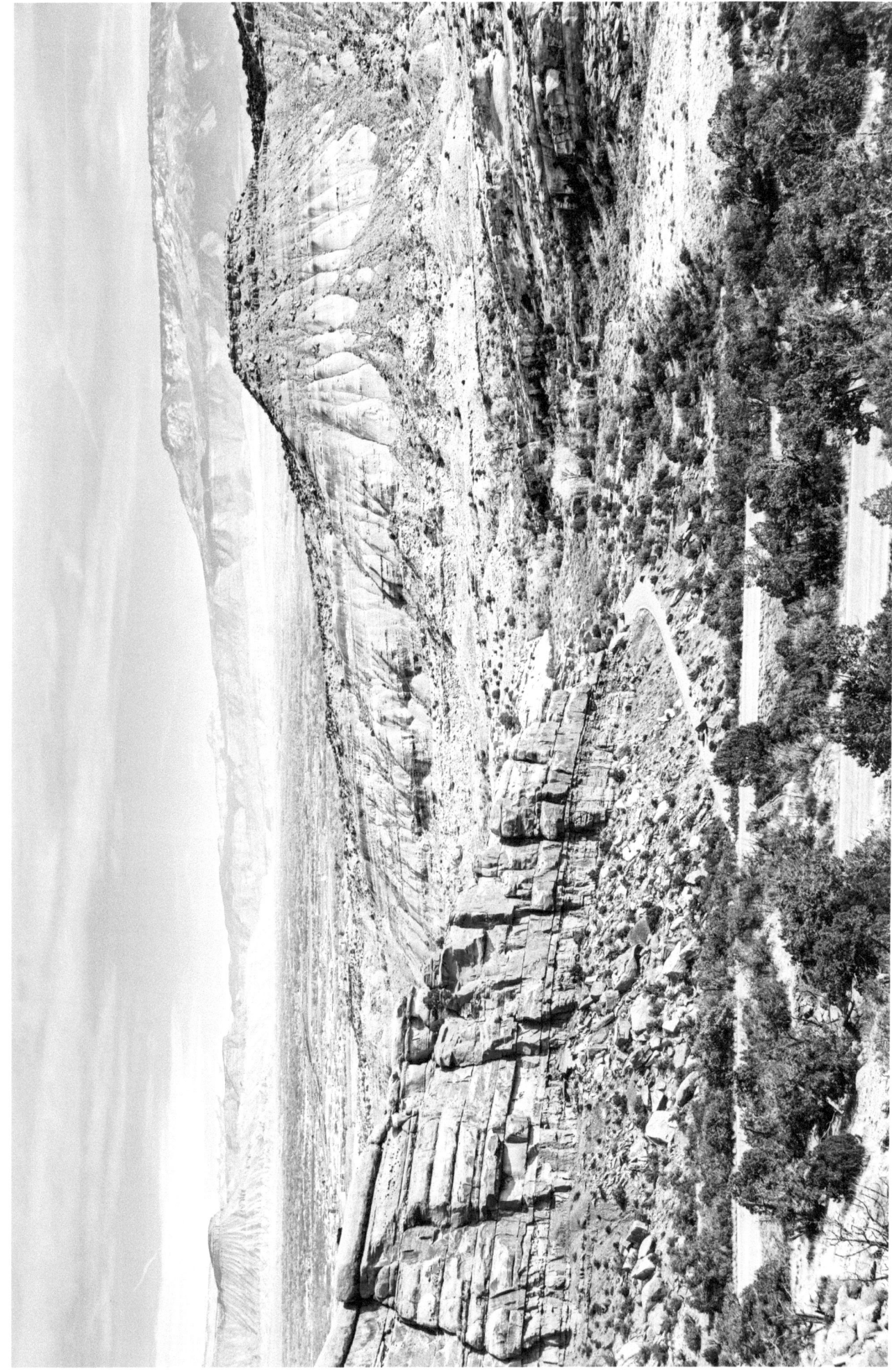

Page is intentionally blank to prevent bleed-through.

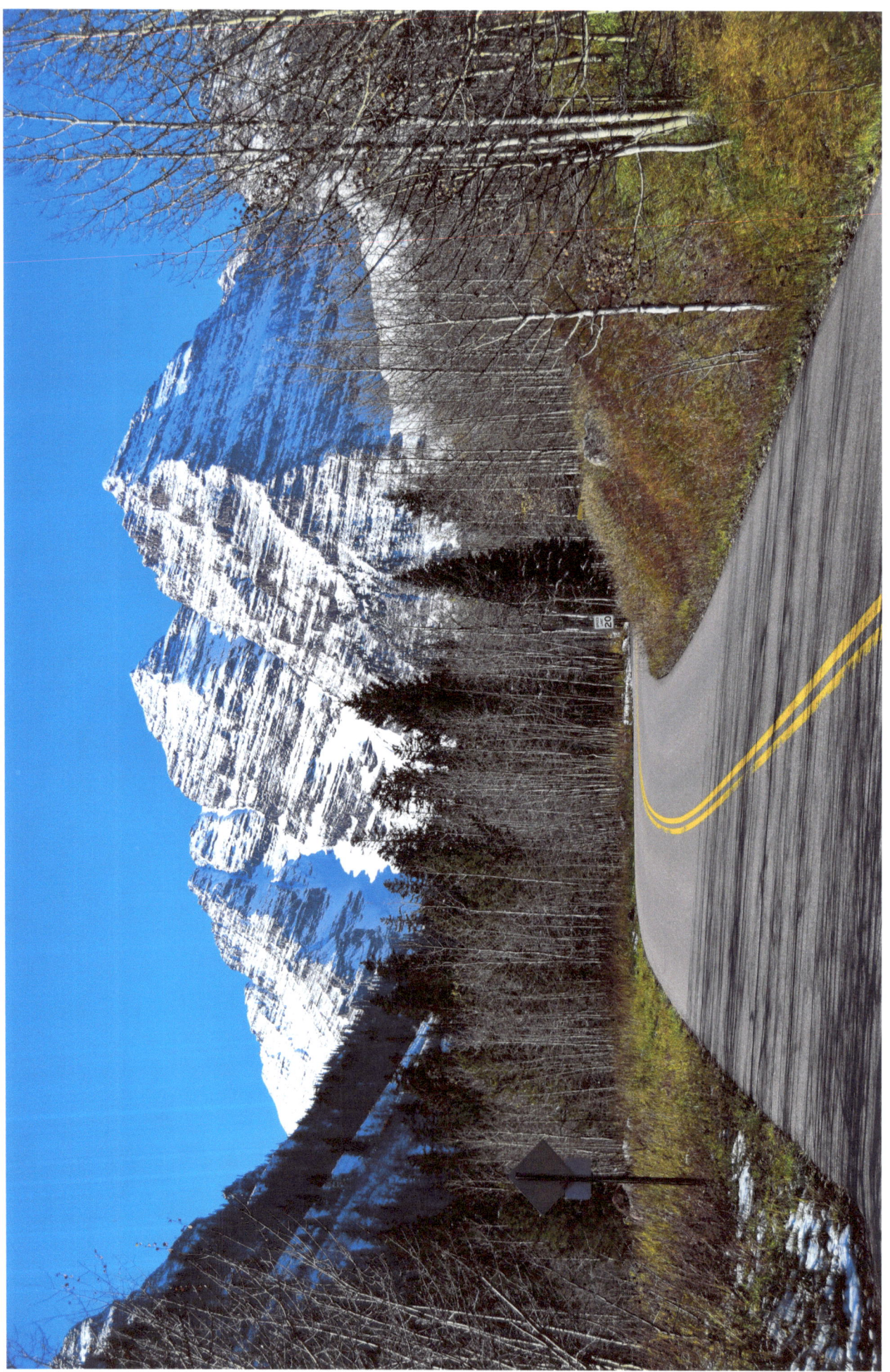

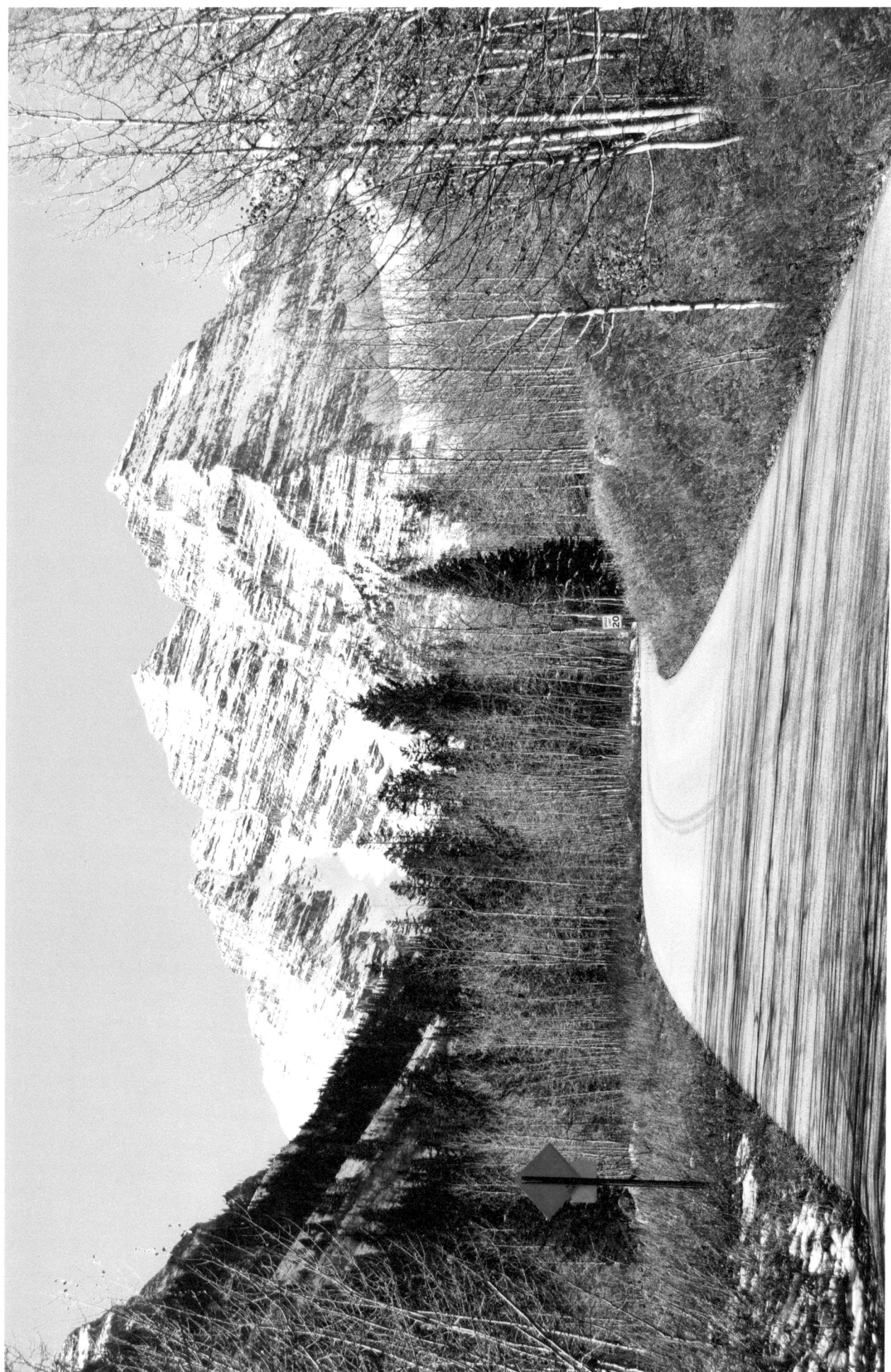

Page is intentionally blank to prevent bleed-through.

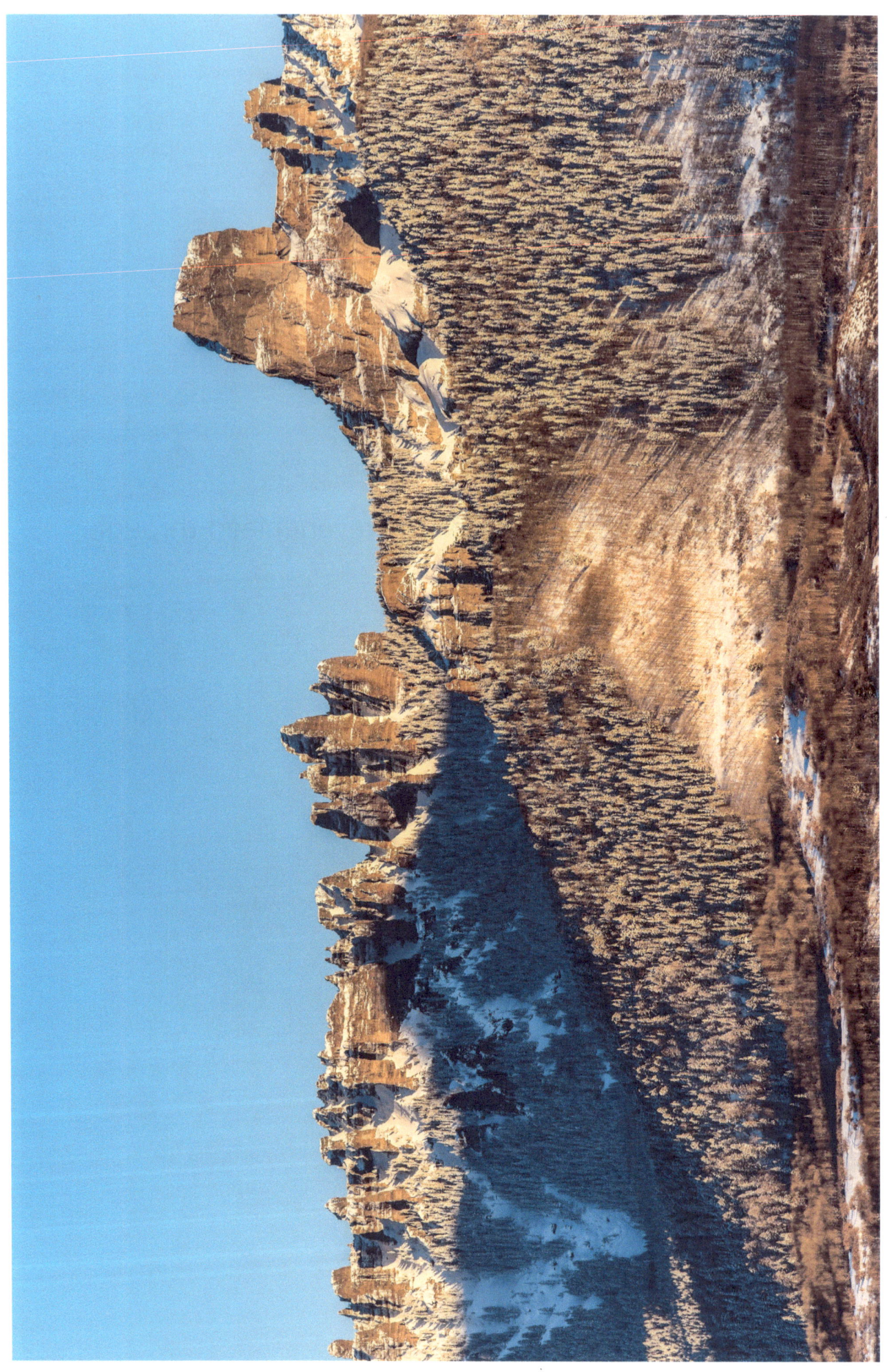

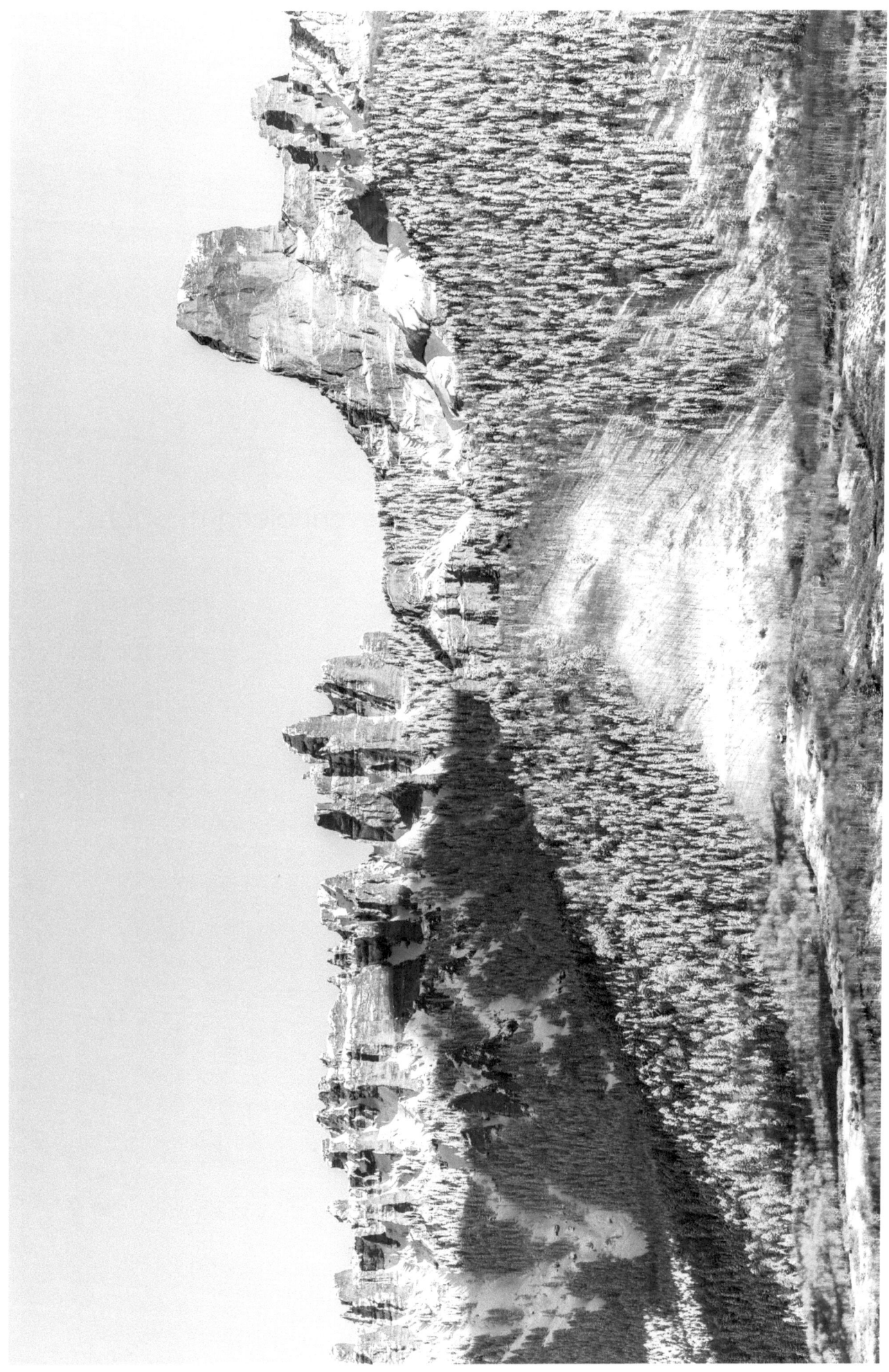

Page is intentionally blank to prevent bleed-through.

Page is intentionally blank to prevent bleed-through.

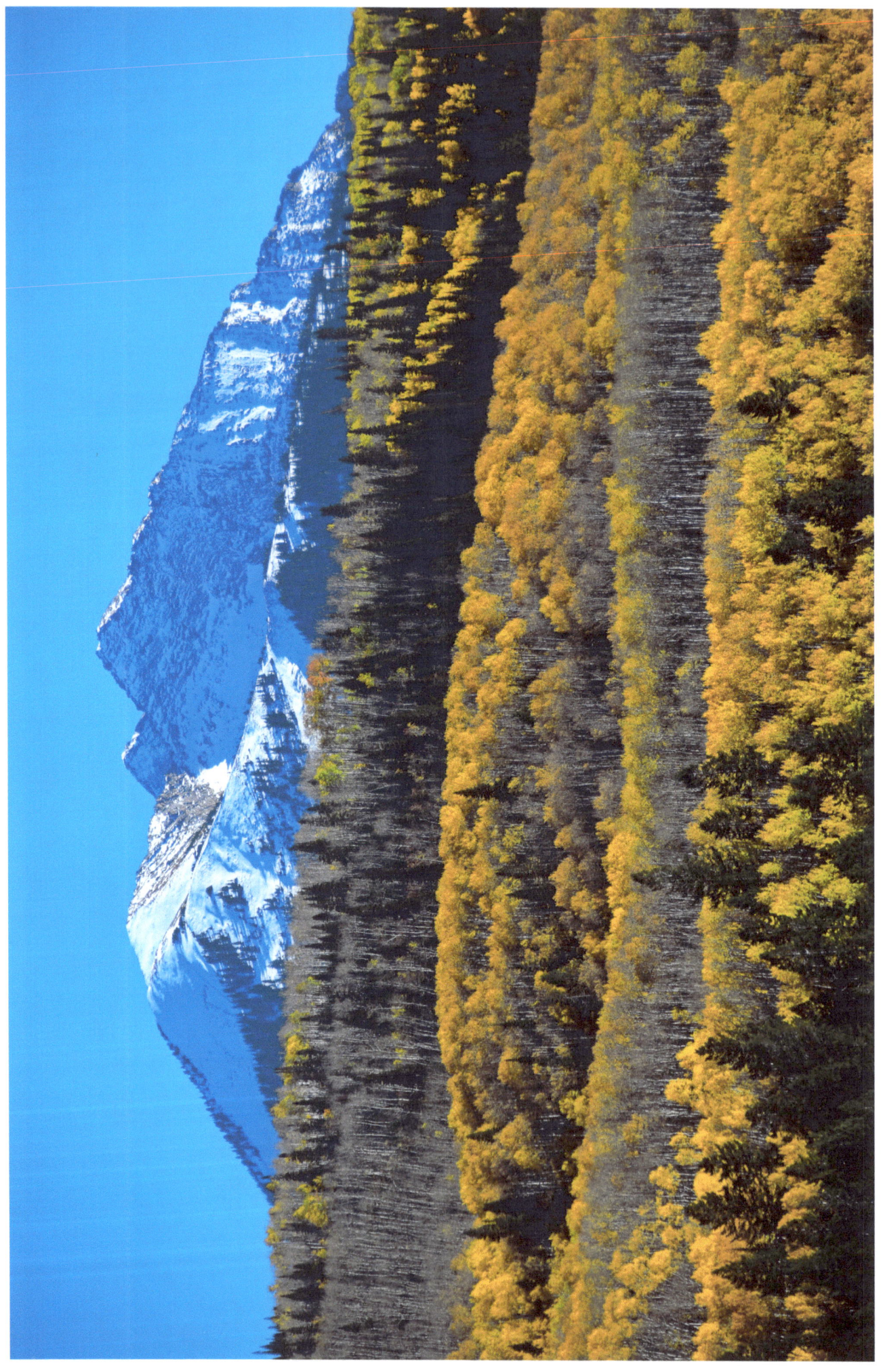

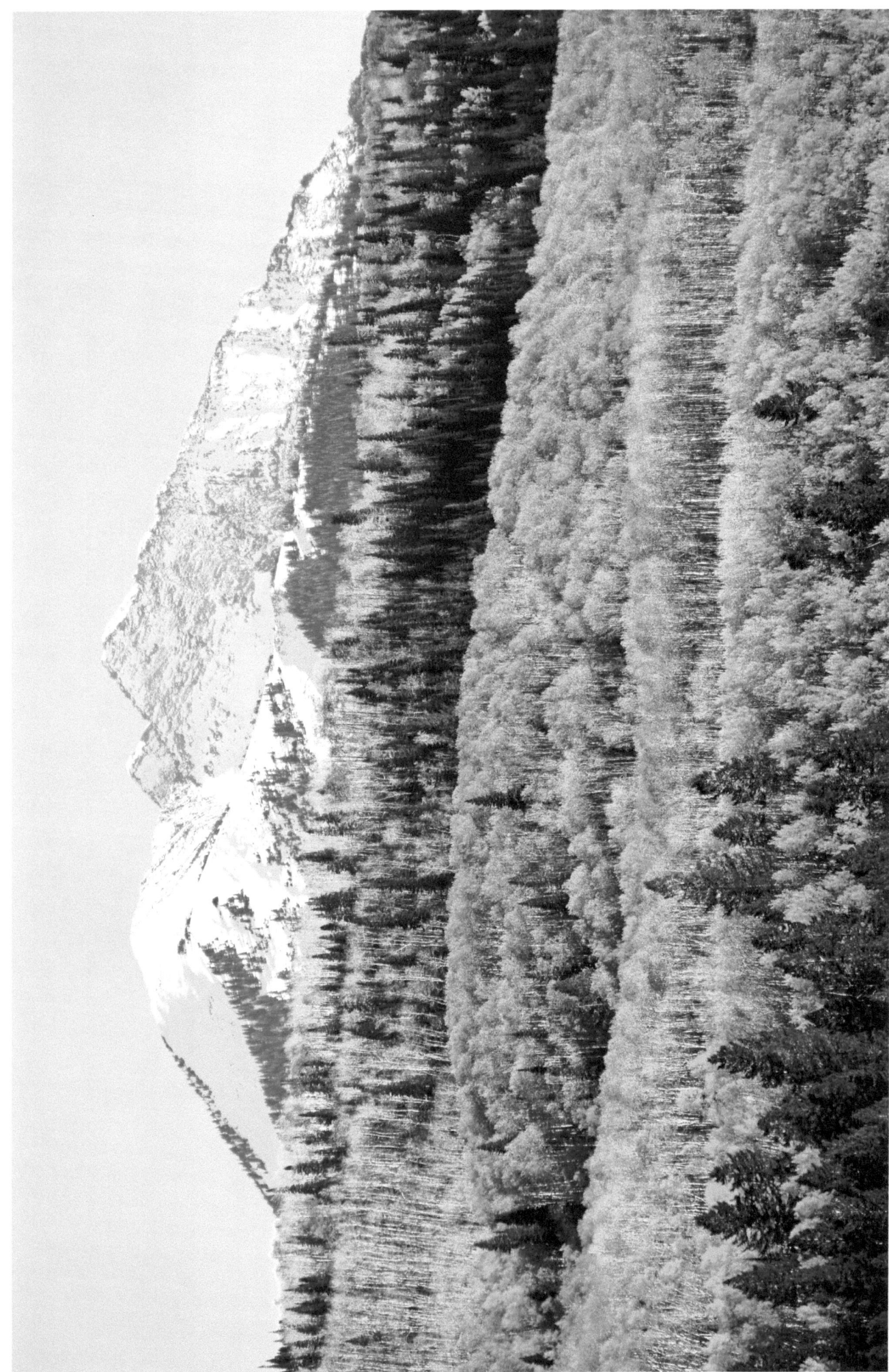

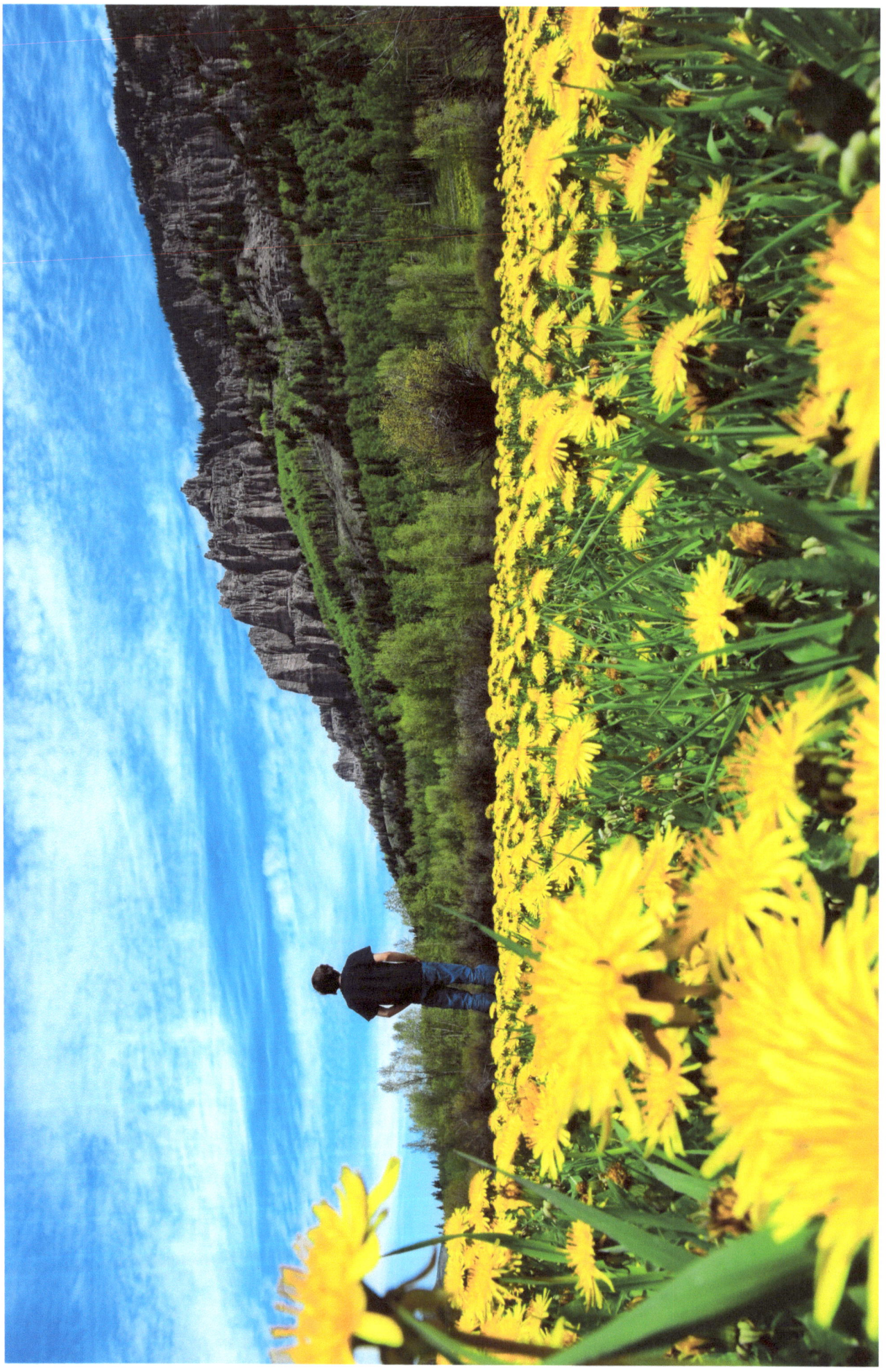

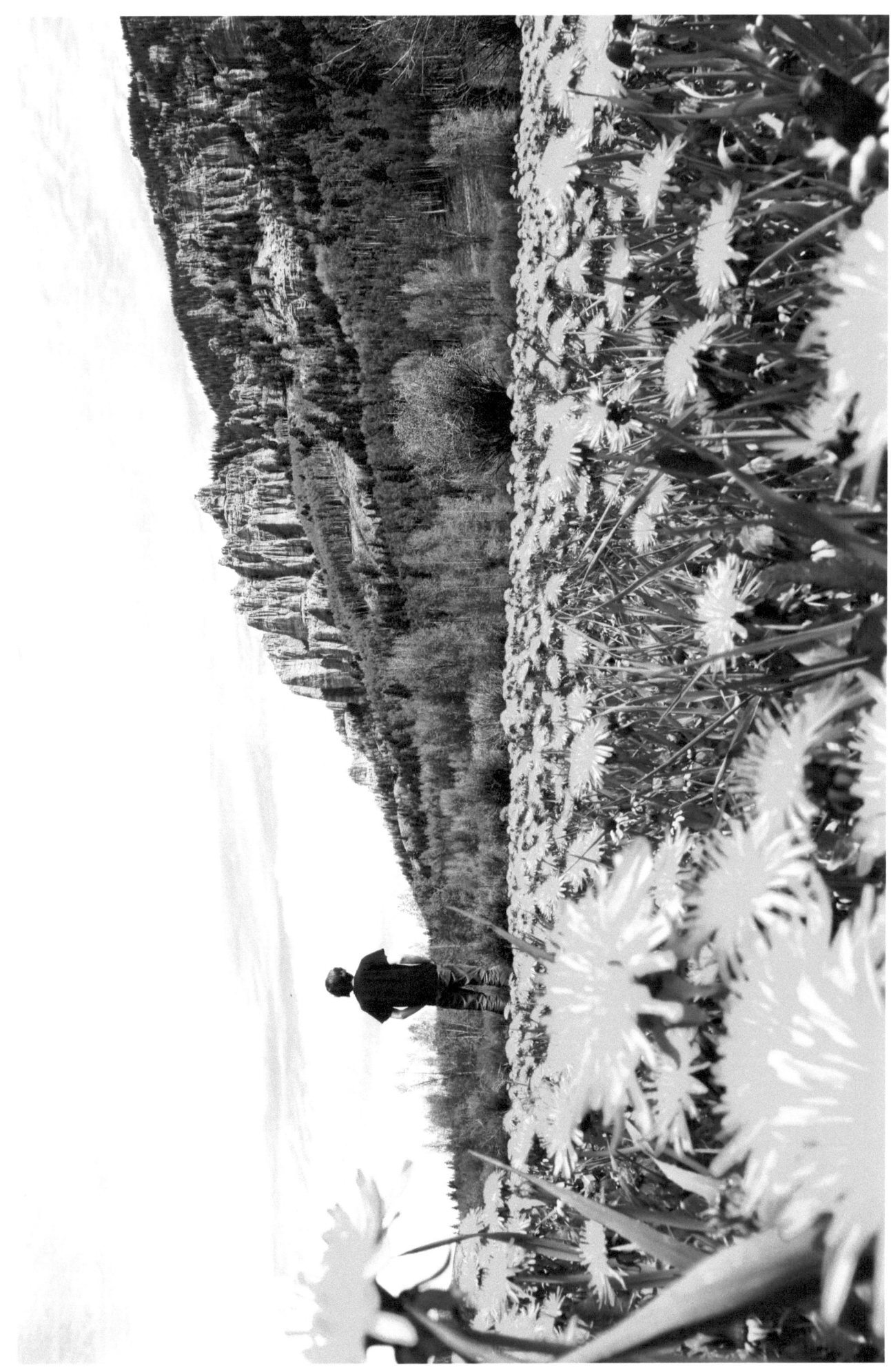

Page is intentionally blank to prevent bleed-through.

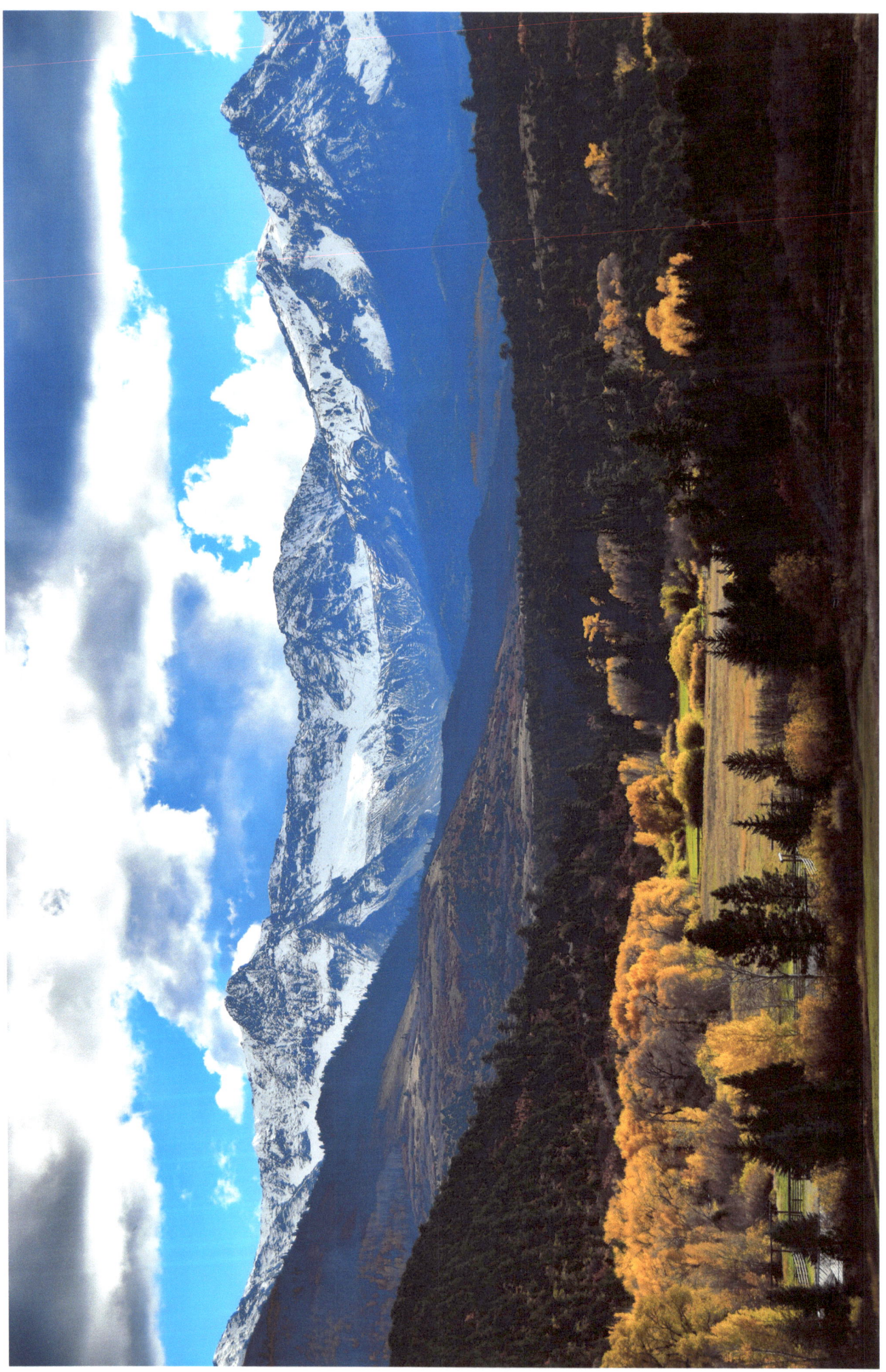

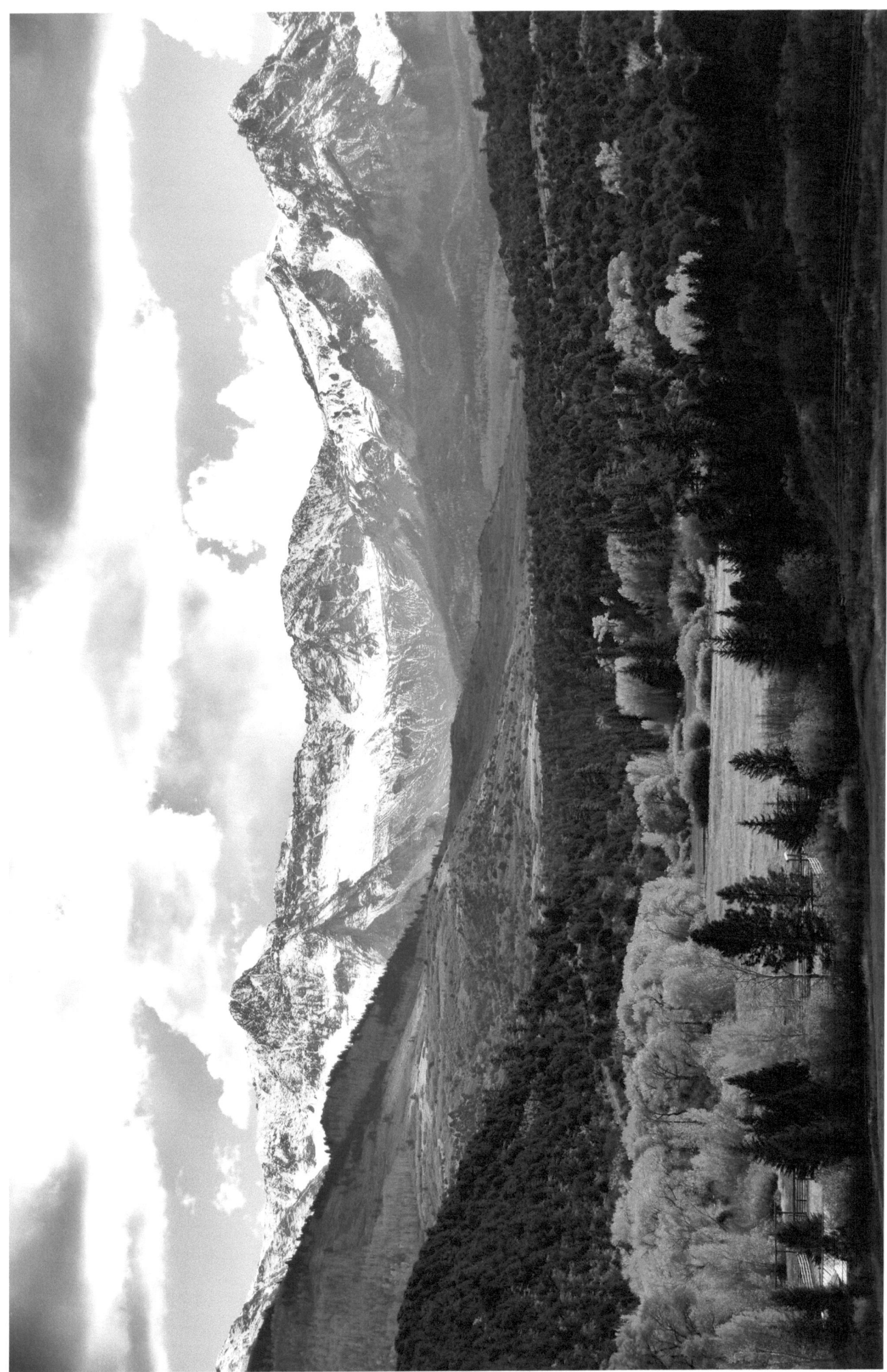

Page is intentionally blank to prevent bleed-through.

Page is intentionally blank to prevent bleed-through.

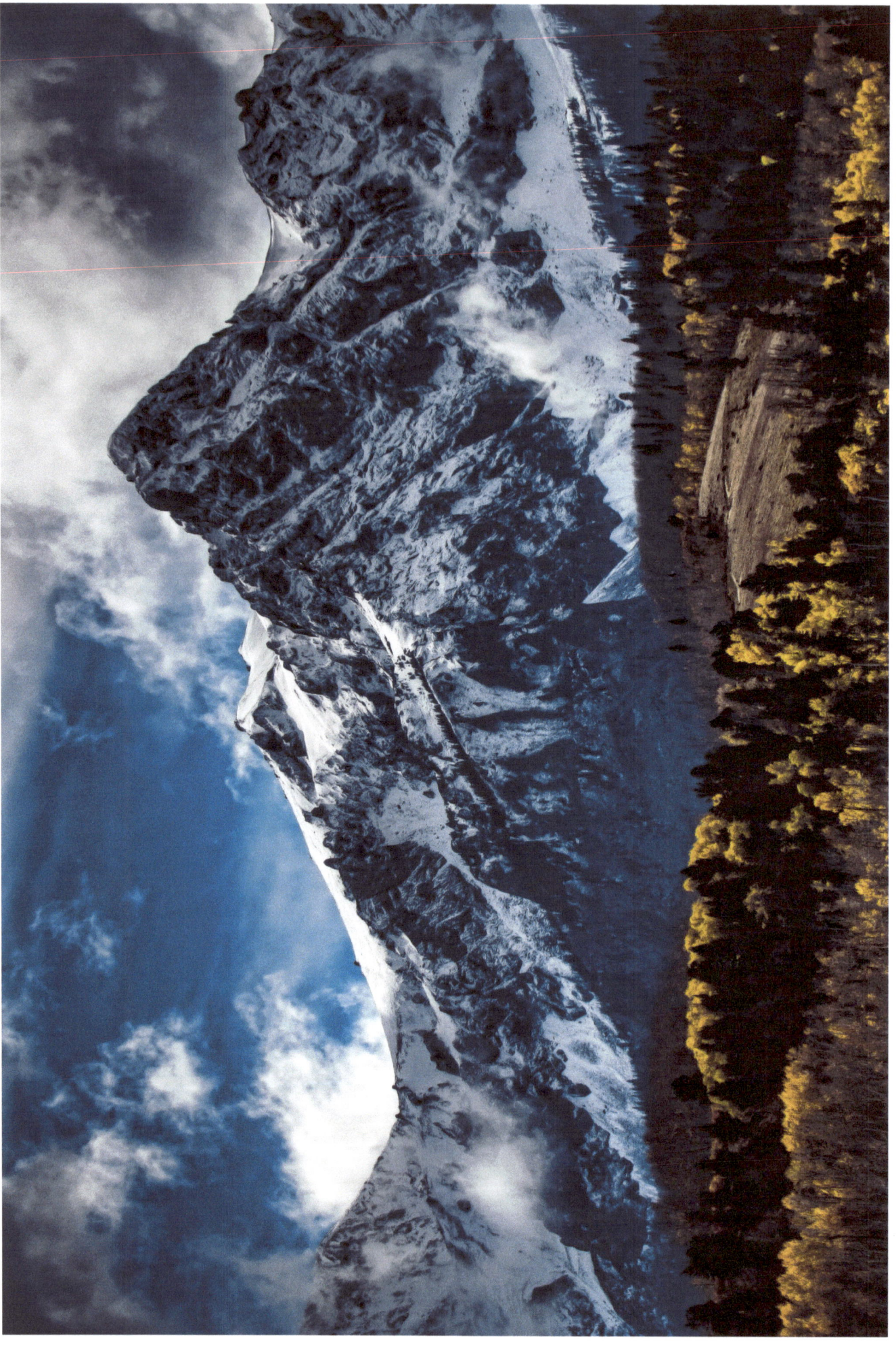

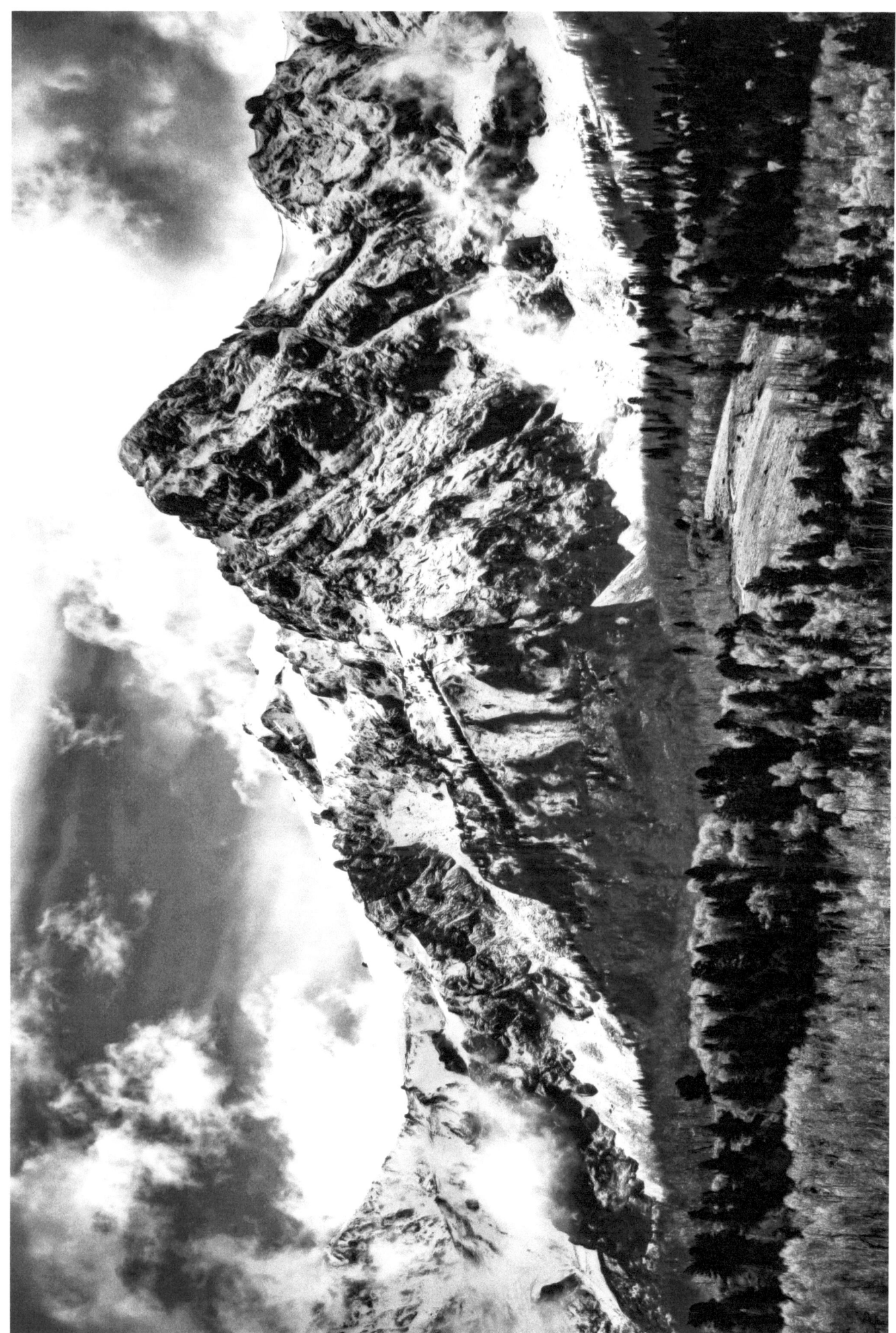

Page is intentionally blank to prevent bleed-through.

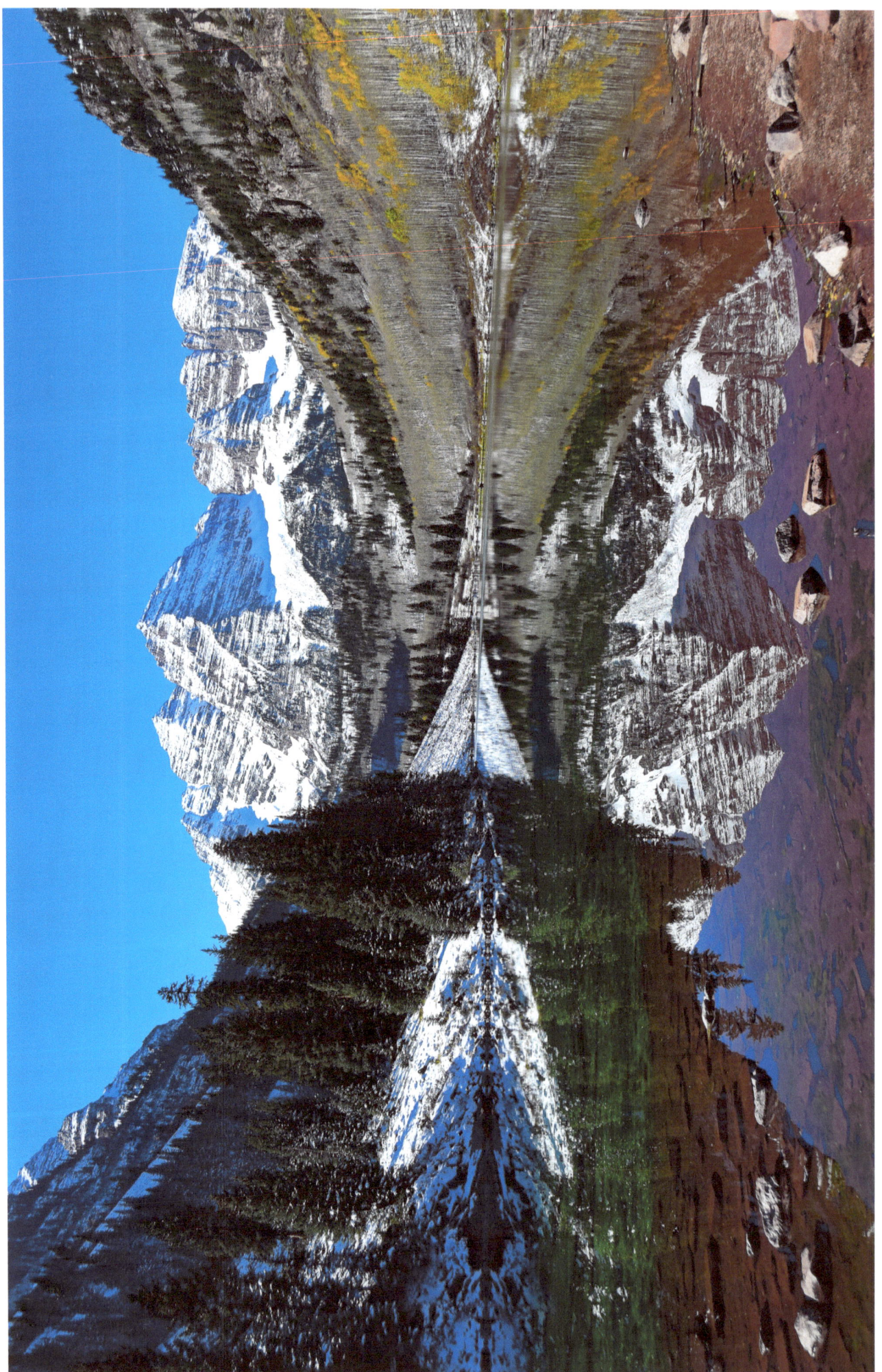

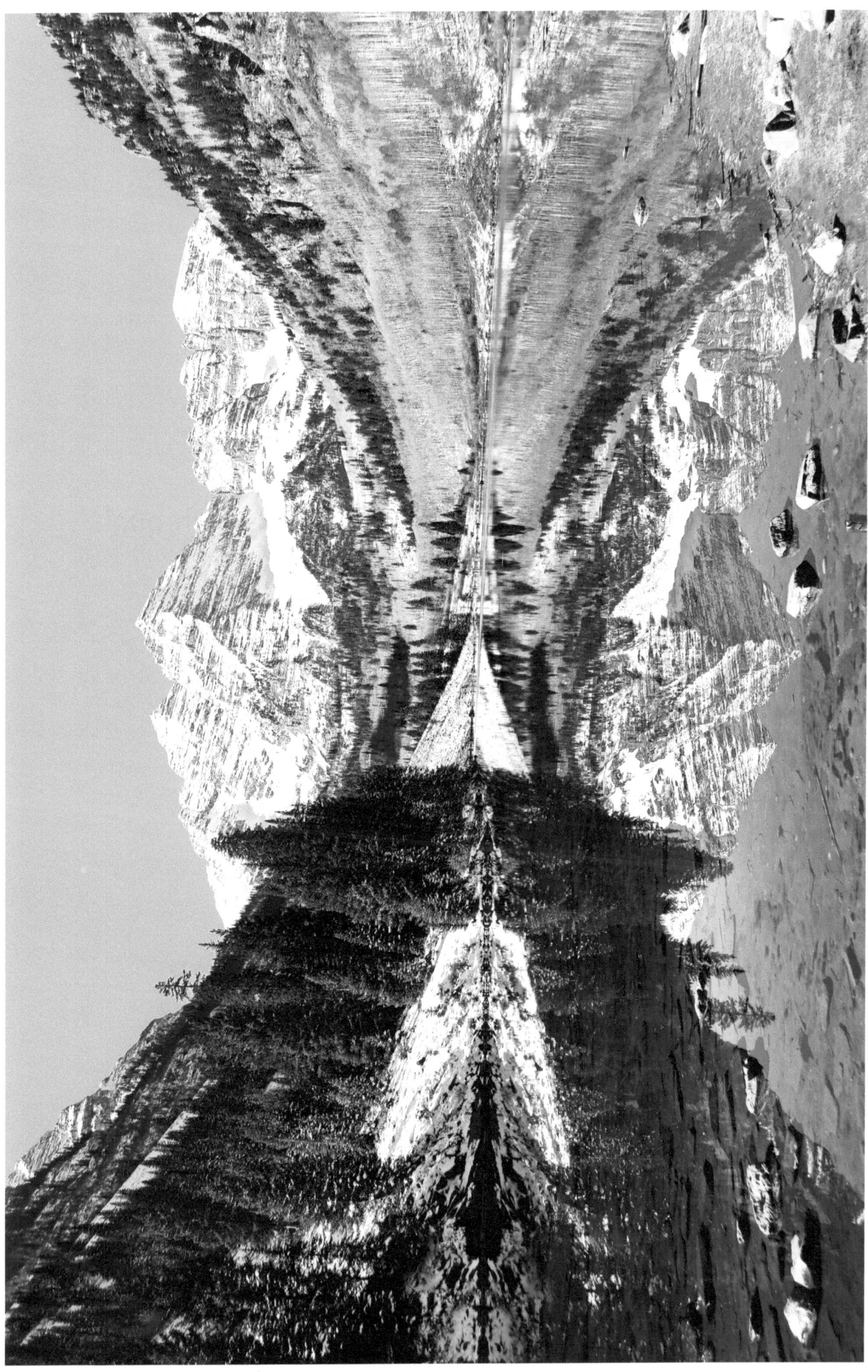

Page is intentionally blank to prevent bleed-through.

Page is intentionally blank to prevent bleed-through.

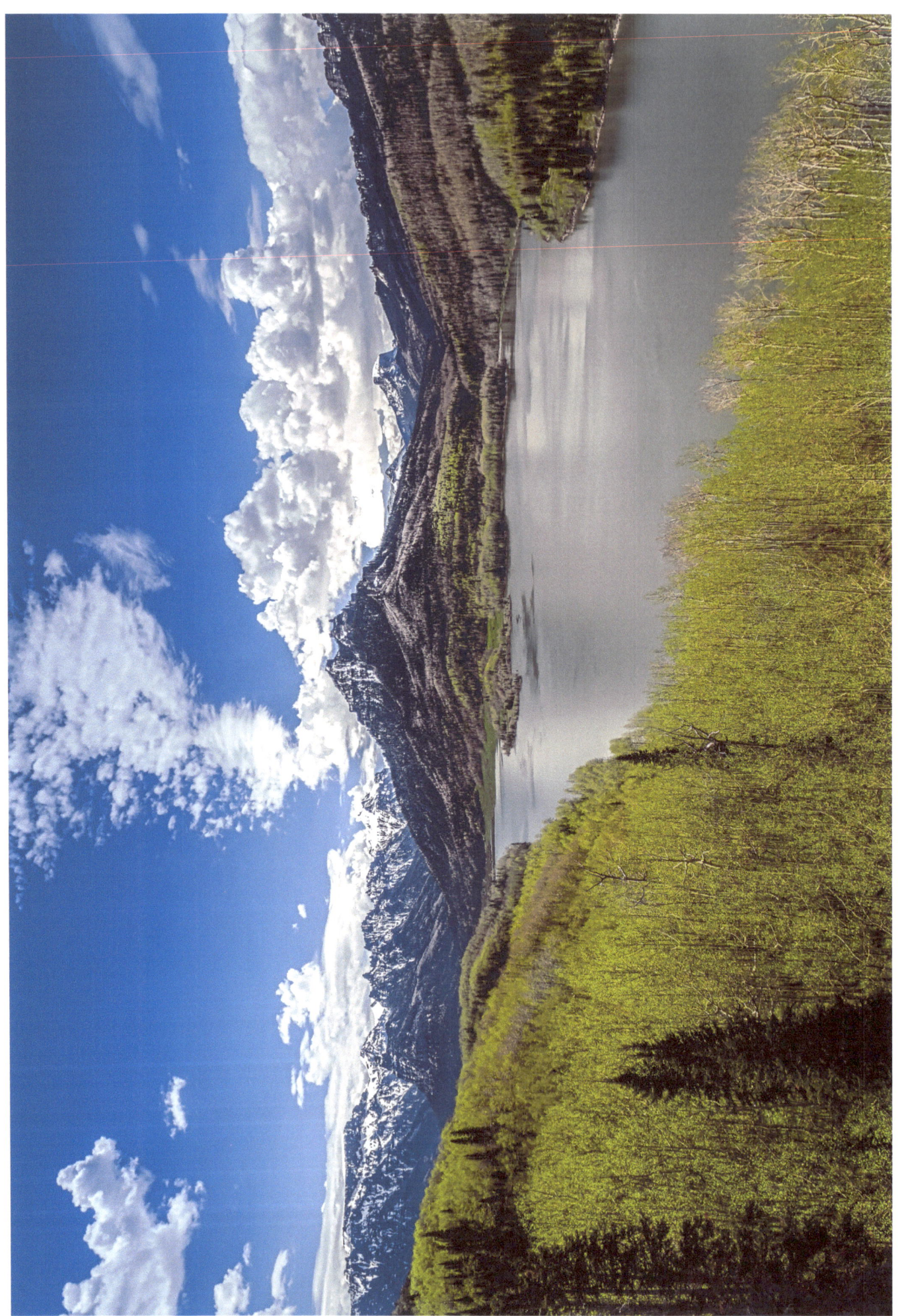

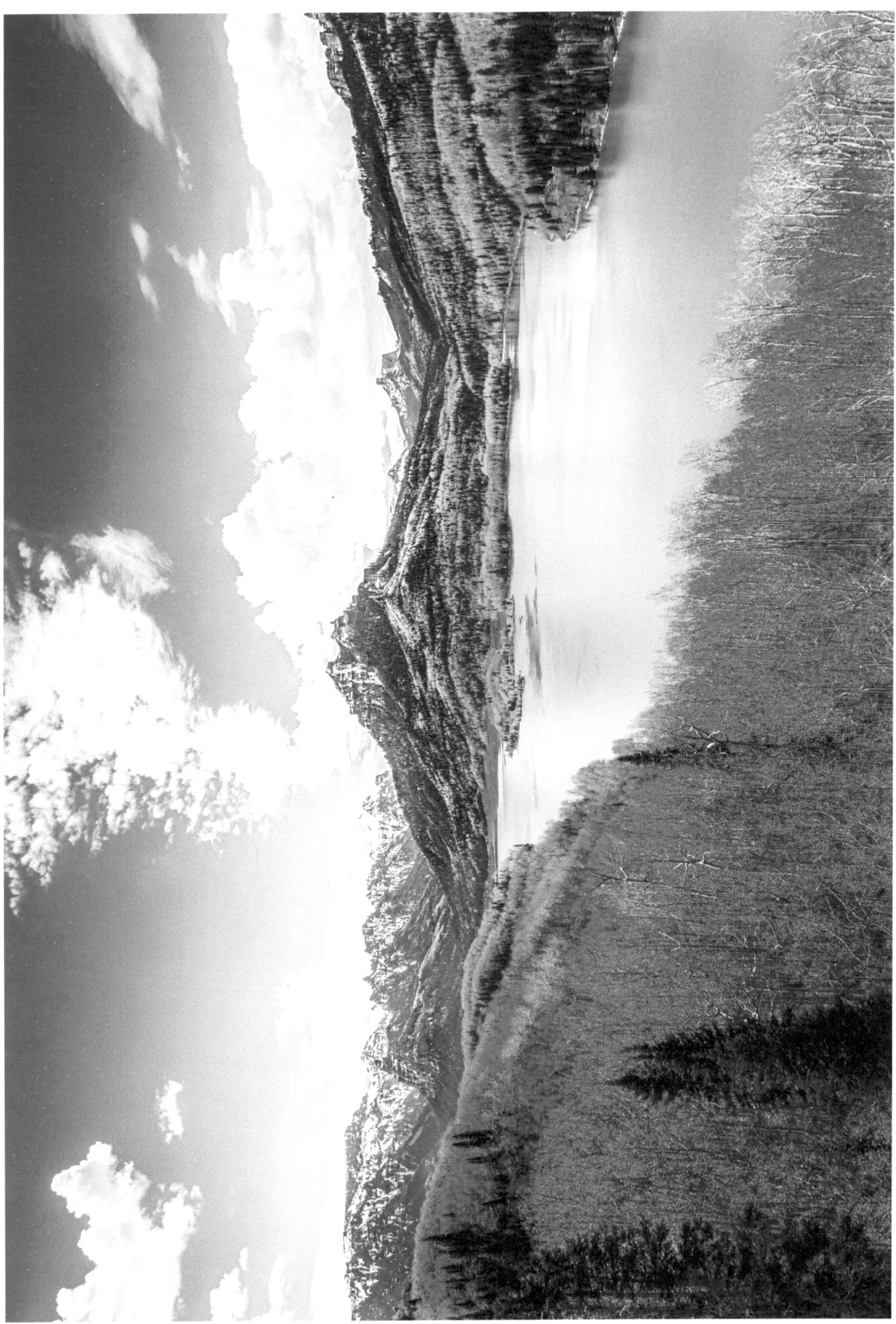

www.ingramcontent.com/pod-product-compliance
Lightning Source LLC
Chambersburg PA
CBHW050354180526
45159CB00005B/2015